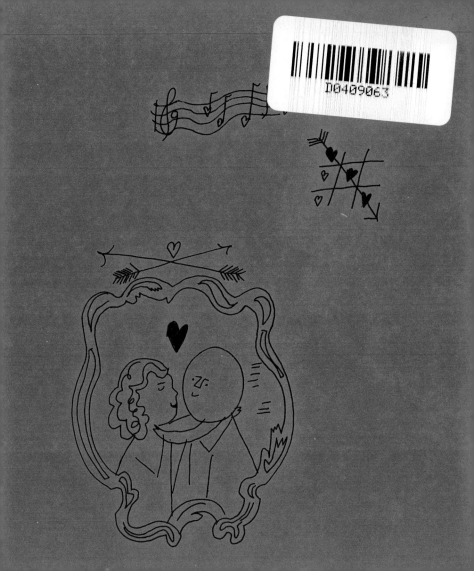

February 14, 1996

When I read some of these lines, it reminded me of how I love you.

"He kissed me on the cheek, which was so tender," was just the beginning of our love. I will never forget how I felt when you kissed me that first evening.

I love you, Ralph!

Kathy

LOVE, LOVE, LOVE

LOVE, LOVE, LOVE

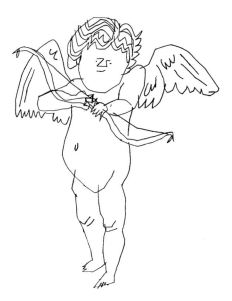

ANDY WARHOL

A BULFINCH PRESS BOOK

LITTLE, BROWN AND COMPANY BOSTON NEW YORK TORONTO LONDON

FIRST EDITION
Quotations from Andy Warhol compiled by R. Seth Bright
Designed by John Kane

Library of Congress Cataloging-in-Publication Data

Warhol, Andy, 1928–1987.
 Love, love, love / Andy Warhol. — 1st ed.
 p. cm.
 "A Bulfinch Press Book."
 Includes bibliographical references.
 ISBN 0-8212-2132-9
 1. Warhol, Andy, 1928–1987 — Themes, motives. 2. Love in art.
I. Title.
 NC139.W37A4 1995
 741.973 — dc20 95-2261

Bulfinch Press is an imprint and trademark of
Little, Brown and Company (Inc.)
Published simultaneously in Canada by
Little, Brown & Company (Canada) Limited

PRINTED IN SINGAPORE

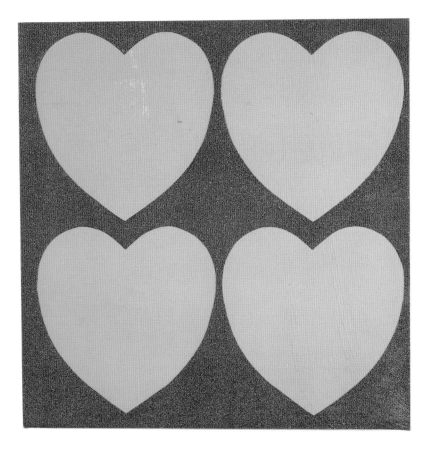

People should
fall in love
with their eyes
closed.

Just close
your eyes.

Don't
look.

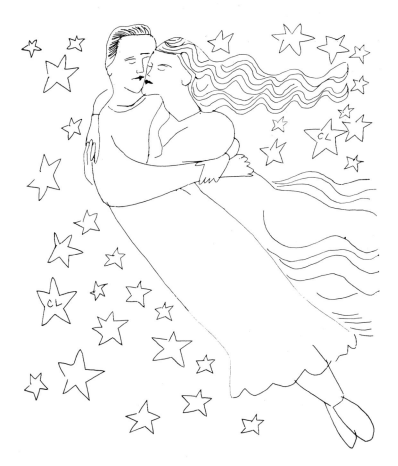

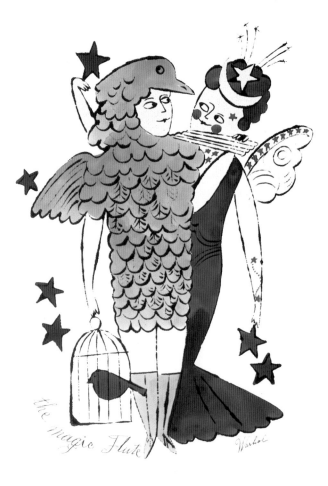

the magic Flute

Warhol

And it's magic.

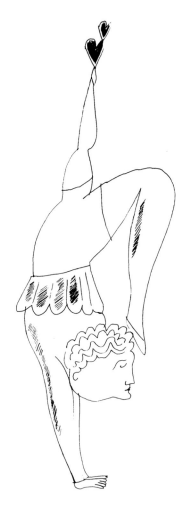

There are occasions

when you don't want people to talk to you.

But the trouble with moods is that they're always changing,

sometimes really

fast.

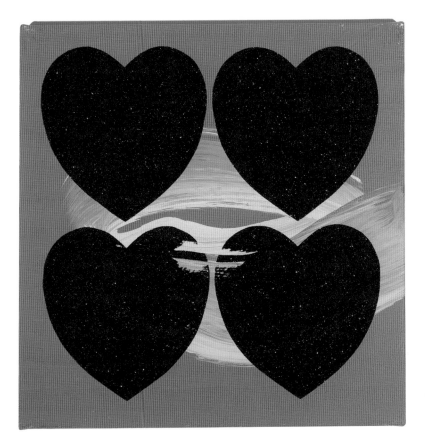

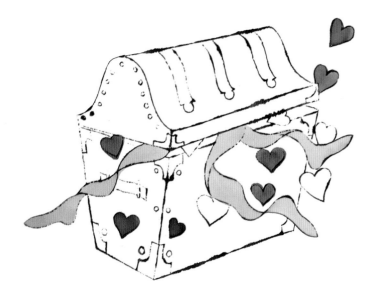

And then, my dear,
 it was like

a storybook
fairy tale.

You should have contact with your closest friends through the most intimate and exclusive of all media—

the telephone.

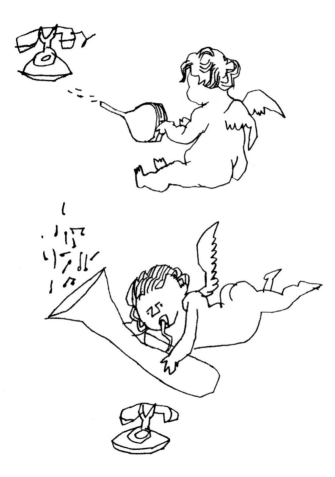

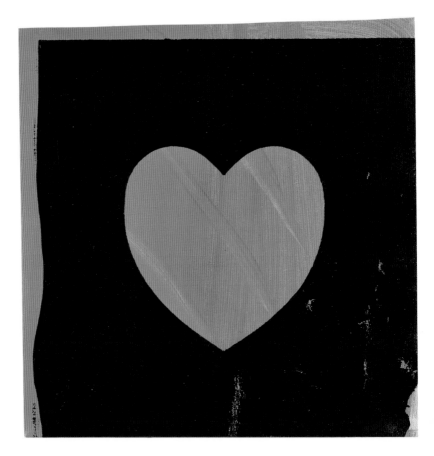

You need to let little things that would ordinarily bore you suddenly thrill you.

Sometimes you're invited to a

big ball

and for months

you think about how

glamorous and exciting

it's going to be.

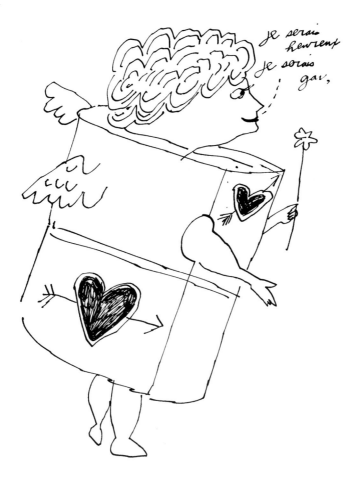

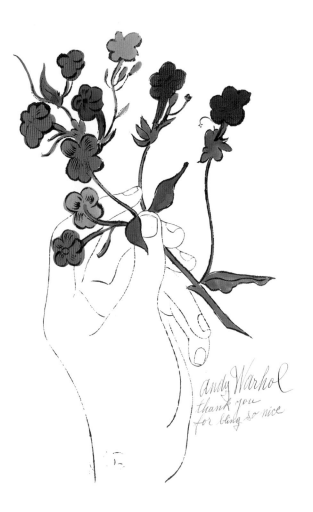

andy Warhol
thank you
for being so nice

When you're interested in somebody, and you think they might be interested in you, you should point out all your

beauty problems and defects

right away,

rather than take a chance they won't notice them.

I get very nervous

when I think
someone is
falling in love
with me.

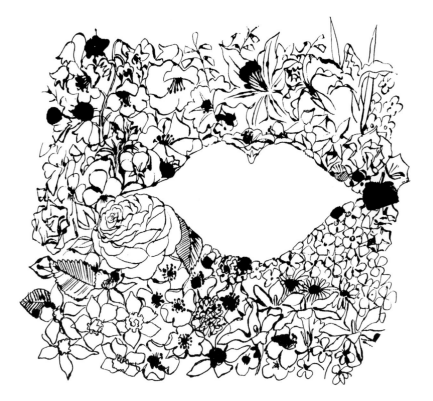

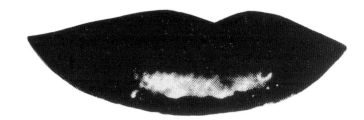

He kissed me on the cheek, which was so tender.

I tried and tried

when I was younger

to learn something about love,

and since it wasn't taught in school

I turned to the

movies

for some clues about what love is

and what to do about it.

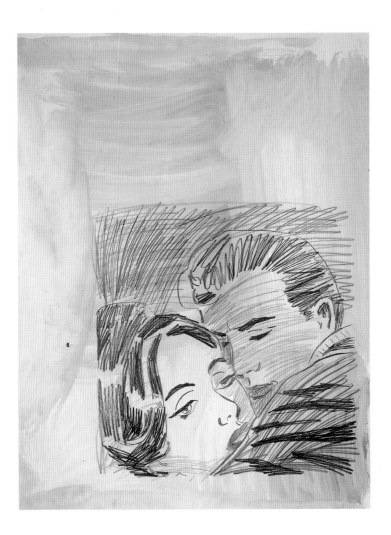

The moment you label something

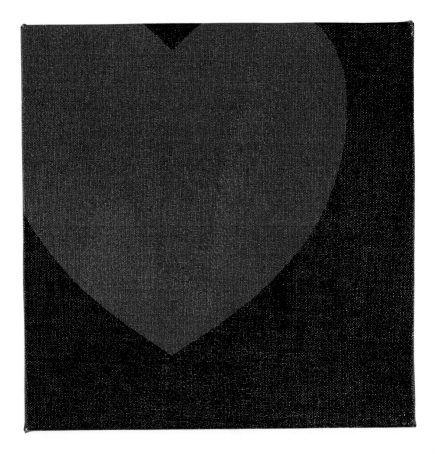

you take a step.

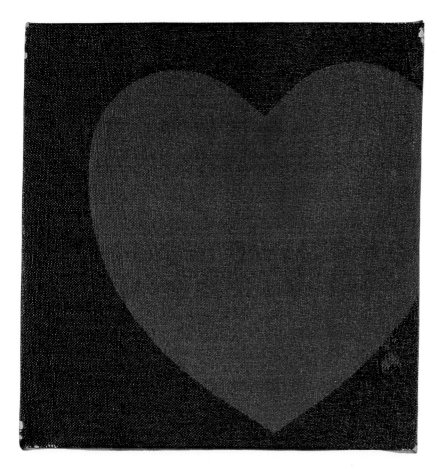

I wonder
if it's possible
to have a

love affair that

lasts

forever.

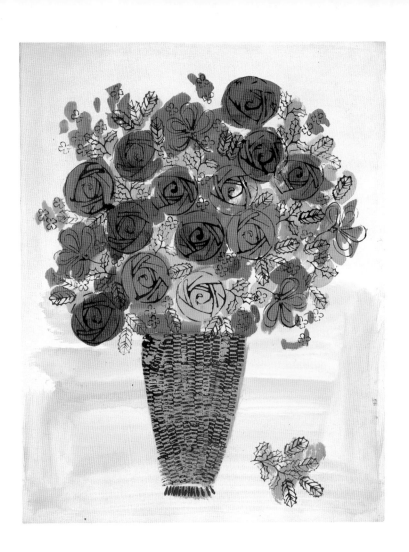

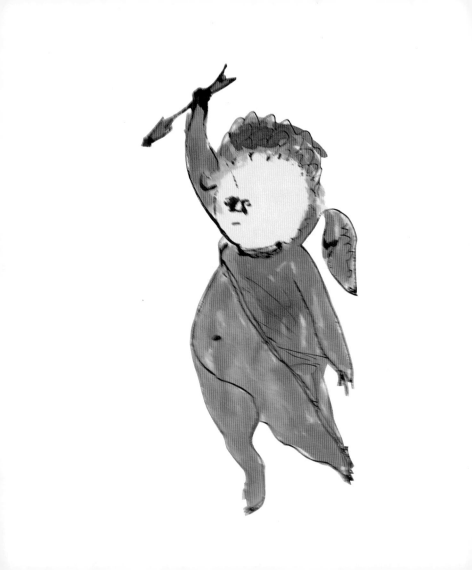

Over the years

I've been more successful at dealing with love than with jealousy.

I get jealousy attacks all the time.

Everybody has a
different idea of
love.

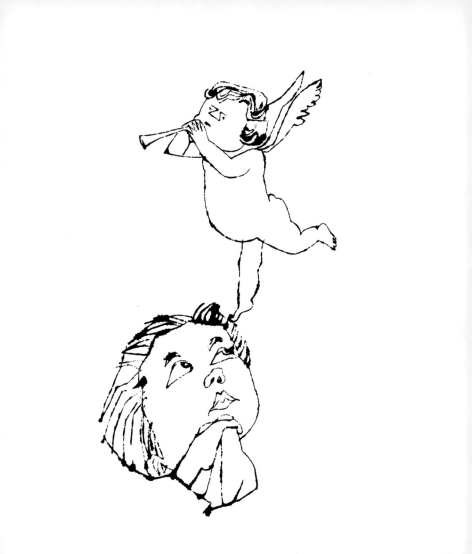

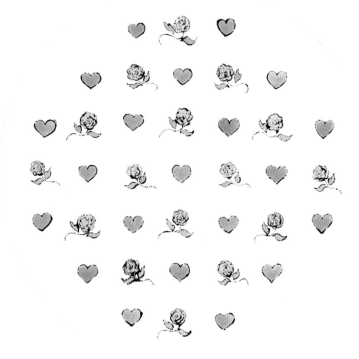

But

you can only live life in
one place
at a time.

The mystery was gone,

but the

amazement

was just starting.

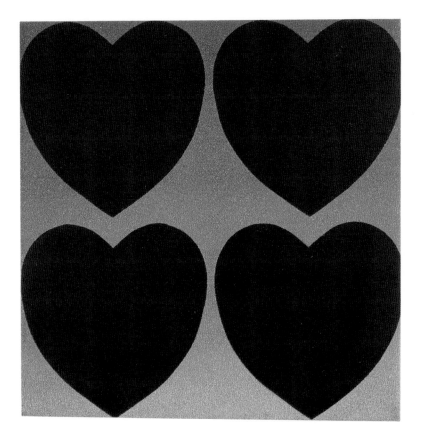

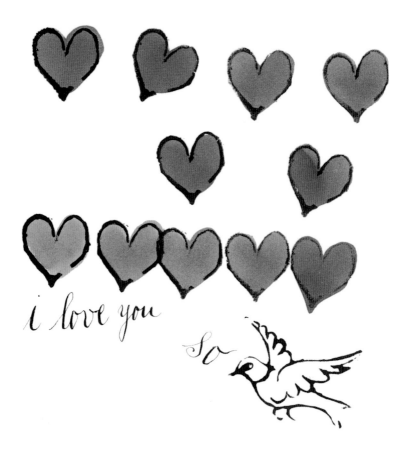

i love you

so

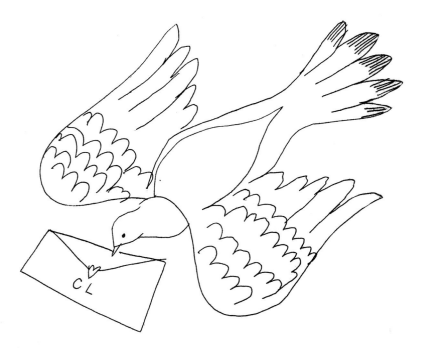

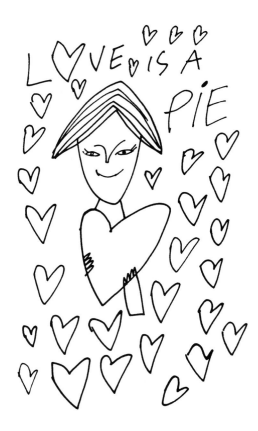

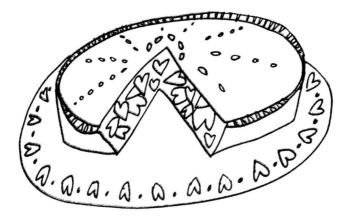

I only stop when I'm

full.

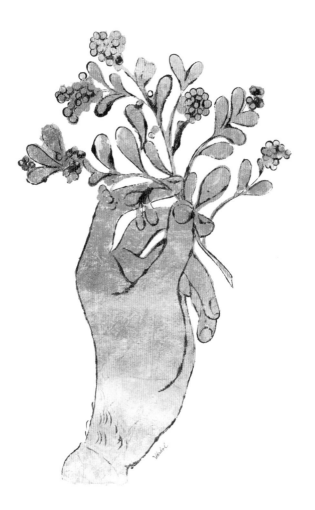

So the first night and the last night would be the most fun,

for different reasons.

I wish I could

talk like that—

I can't think of
those
beautiful
lines.

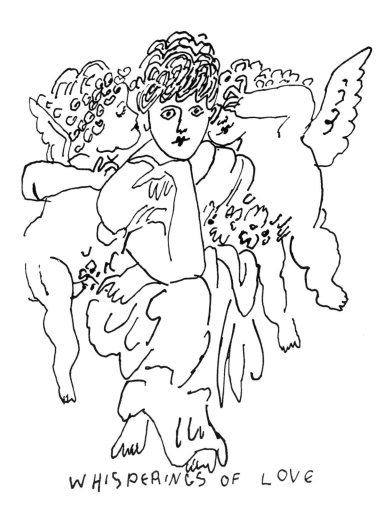

WHISPERINGS OF LOVE

There are
so many
songs
about
love.

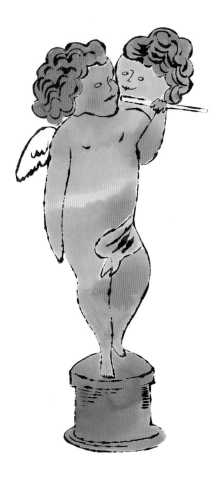

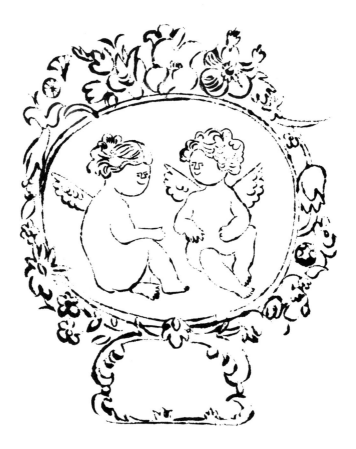

And the best love story is just two love-birds in a cage.

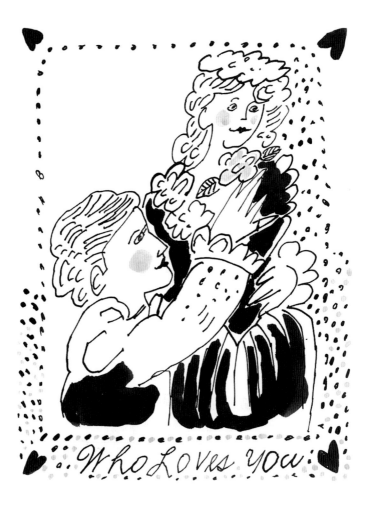

Who Loves You

When you meet someone you never dreamed you'd meet, you're taken by surprise, so you haven't made up any fantasies and you're not let down.

And you can
really see this

glow

coming over
their faces.

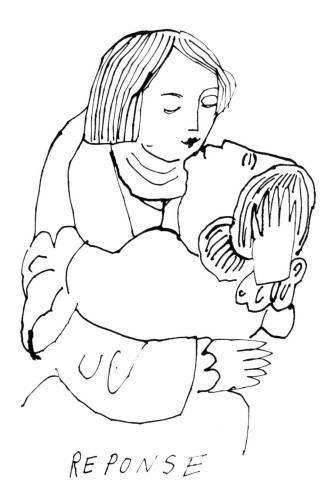

REPONSE

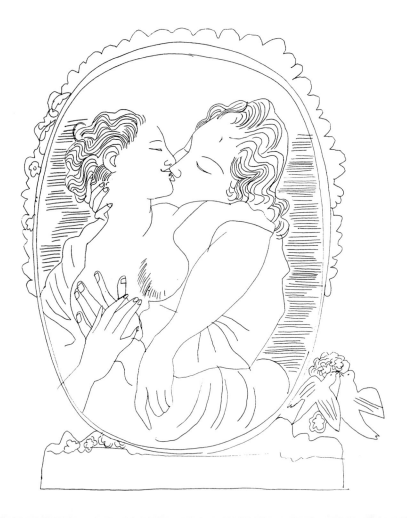

And the fascination
I experienced
was probably very close
to a certain kind of
love.

My ideal wife

would have a lot of bacon,

bring it all home,

and have a
TV station besides.

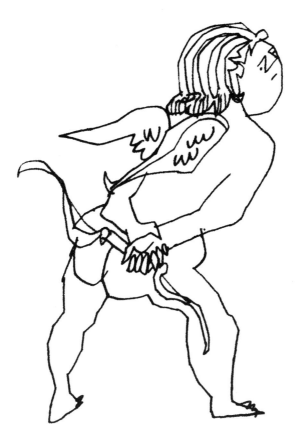

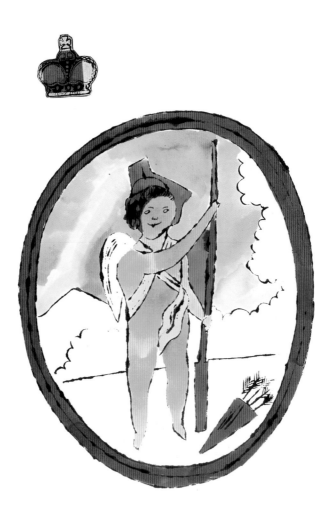

I don't see
anything wrong
with being alone.

It feels great to me.

There should be a course in the first grade on love.

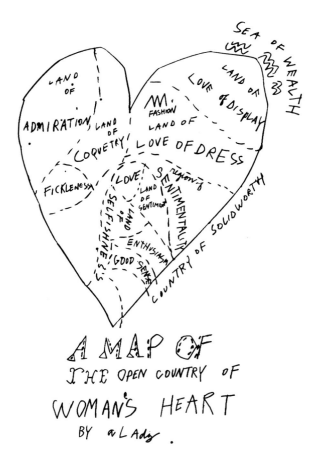

A MAP OF
THE OPEN COUNTRY OF
WOMAN'S HEART
BY a LAdy.

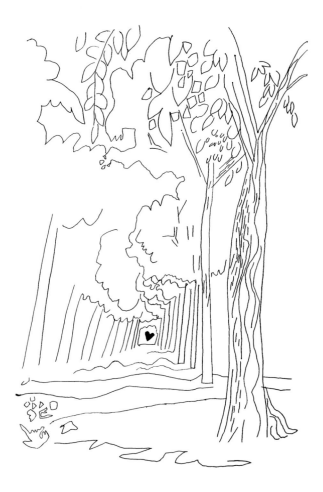

You can be just as faithful

to a place

or a thing

as you can

to a person.

What I like are things that are

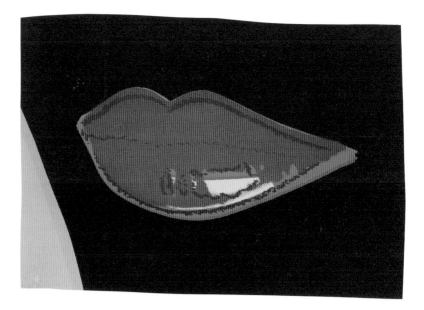

different

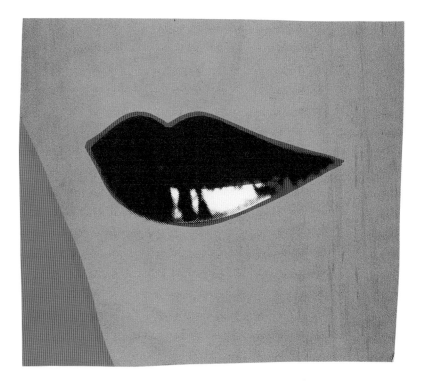

every time.

Being single is best,

but

everyone

wants

to fall

in love.

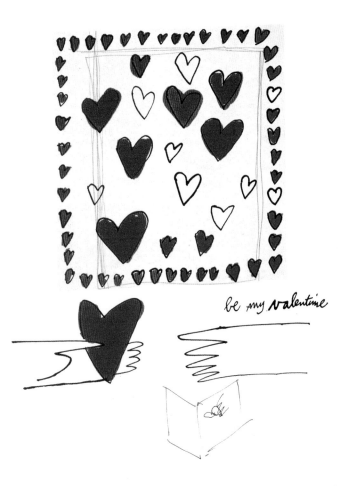

be my *valentine*

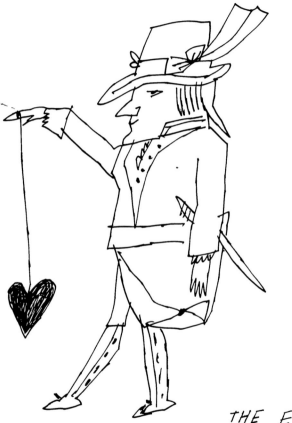

THE END.

All quotations are by Andy Warhol
and were first published as follows:

Pages 6, 16, 20, 23, 24, 28, 32, 35, 36, 52, 55, 57, 61, 62, 65, 66, 69, 70-71:
 Andy Warhol. *The Philosophy of Andy Warhol (from A
 to B and Back Again)*. New York: Harcourt Brace
 Jovanovich, 1975.

Pages 9, 12, 30-31, 39, 40, 58, 72:
 Andy Warhol. *America*. New York: Harper & Row, 1985.

Pages 10-11, 19, 47, 49:
 Andy Warhol and Pat Hackett. *Andy Warhol's Party
 Book*. New York: Crown Publishers, 1988.

Pages 15, 27, 50:
 Pat Hackett, Editor. *The Andy Warhol Diaries*.
 New York: Warner Books, 1989.

Captions by page number

Cover
Untitled, c. 1950s
Ink and ink wash on
Strathmore paper
14 1/2" x 11 1/4"

Endpapers
Sketch for Bonwit Teller Window Display, c. 1959
Black ballpoint on tan paper

3 *Sprite Angel with Bow*, c. 1951
Graphite on off-white
bond paper
11" x 8 1/2"

5 *Hearts*, 1979
Synthetic polymer paint and
silkscreen ink on canvas
15" x 15"

7 *Male and Female Figure*,
c. 1954–55
Black ballpoint on manila
paper
16 3/4" x 13 7/8"

8 *The Magic Flute*, c. 1959
Ink and ink wash on
Strathmore paper
22 5/8" x 14 3/4"

10 *Male Costume Figure*, c. 1954–55
Ink on tan paper
16 3/4" x 13 7/8"

13 *Valentine's Hearts*, 1979
Synthetic polymer paint,
silkscreen ink, and diamond
dust on canvas
16" x 16"

14 *Chest*, c. 1959
Ink, wash, and tempera on
Strathmore paper
14" x 11 1/2"

17 *Two Sprite Angels with Telephone*, c. 1950
Graphite on off-white bond
paper
11" x 8 1/2"

18 *Heart*, 1979
Synthetic polymer paint and
silkscreen ink on canvas
14" x 14"

41 *Hearts*, 1979
 Synthetic polymer paint,
 diamond dust, and silkscreen
 ink on canvas
 14" x 14"

42 *"I Love You So,"* c. 1960
 Ink and ink wash on ivory
 paper
 9 7/8" x 12 1/4"

43 *Bird with Letter*, c. 1955
 Black ballpoint on manila
 paper
 16 3/4" x 13 7/8"

44 *"Love Is a Pie,"* c. 1951
 Ink on ivory bond paper
 11" x 8 1/2"

45 *Pie with Hearts*, c. 1951
 Ink on ivory bond paper
 11" x 8 1/2"

46 *Heart with Bow*, 1983
 Synthetic polymer paint and
 silkscreen ink on canvas
 14" x 11"

48 *Hand Holding Mistletoe*, c. 1957
 Gold leaf and ink on
 Strathmore paper
 20" x 14"

51 *Whisperings of Love*, c. 1953–54
 Ink on white paper
 11" x 8 1/2"

52 *Two Sprite Angels in Decorative
 Frame*, c. 1951
 Ink on colored graphic art
 paper
 13 1/4" x 11 1/4"

55 *Two Cherubs*, c. 1956
 Ink and ink wash on
 Strathmore paper
 19 1/4" x 13"

56 *"Who Loves You,"* c. 1953–54
 Ink on white paper
 11" x 8 1/2"

59 *Demande Reponse*, c. 1953
 Ink on manila paper
 11" x 8 1/2"